H⬤⬤gs Back Books

- a nose for a good book ...

For Julie – DG
For Mum and Dad. Special thanks to Corinde and Lee – MW
For Rachma – PS

Published by
Hogs Back Books
The Stables
Down Place
Hogs Back
Guildford GU3 1DE
www.hogsbackbooks.com
Text copyright © 2014 David Guy
Illustrations copyright © 2014 Menno Wittebrood and Patrick Schoenmaker
The moral right of David Guy to be identified as the author
and of Menno Wittebrood and Patrick Schoenmaker to be
identified as the illustrators of this work has been asserted.
First published in Great Britain in 2014 by Hogs Back Books Ltd.
Printed in China
ISBN: 978-1-907432-17-0
British Library Cataloguing-in-Publication Data.
A catalogue record for this book is available from the British Library.
1 3 5 4 2

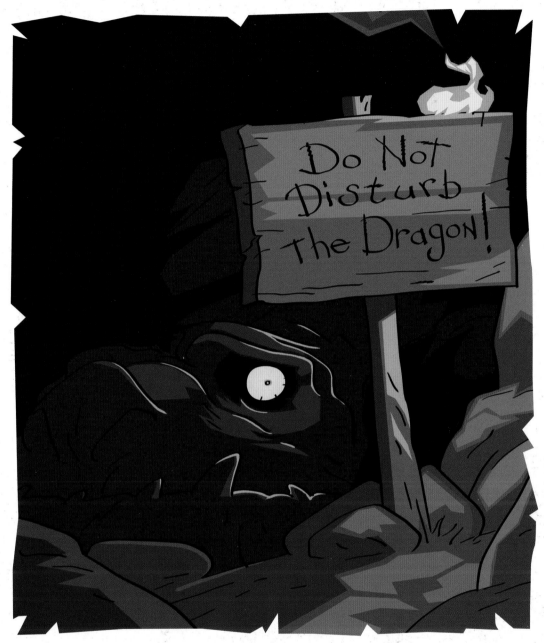

David Guy • Menno Wittebrood • Patrick Schoenmaker

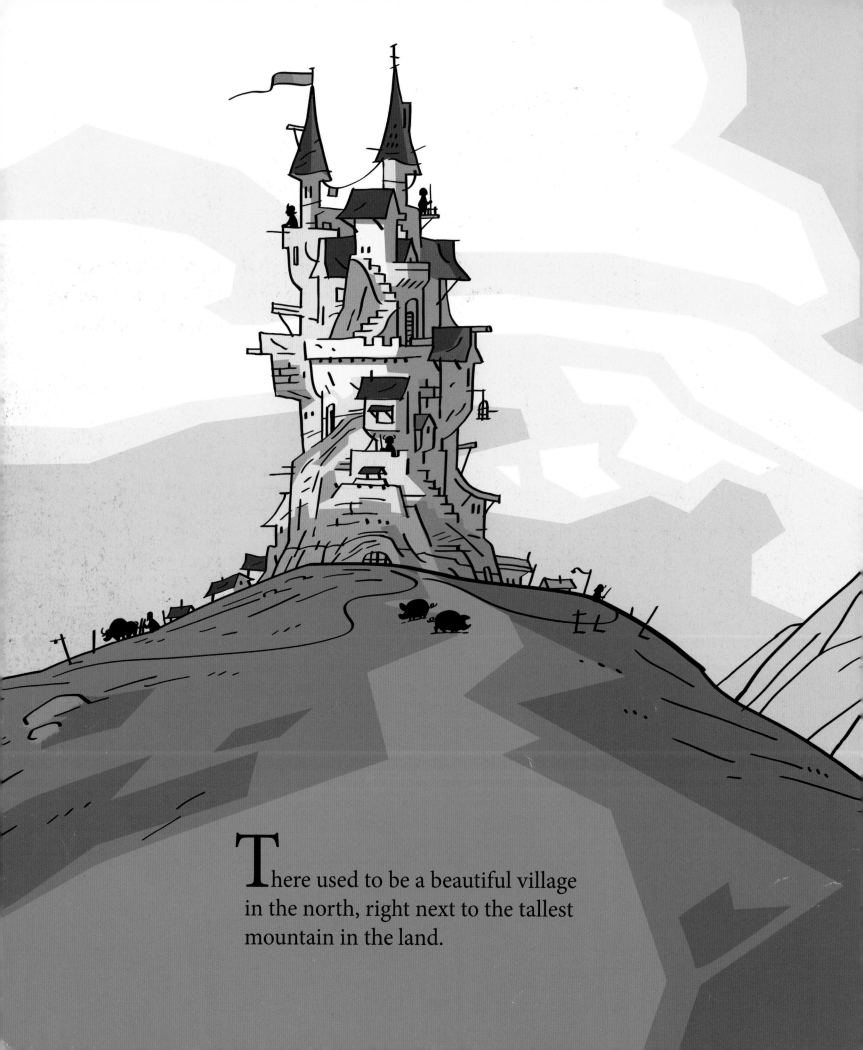

There used to be a beautiful village in the north, right next to the tallest mountain in the land.

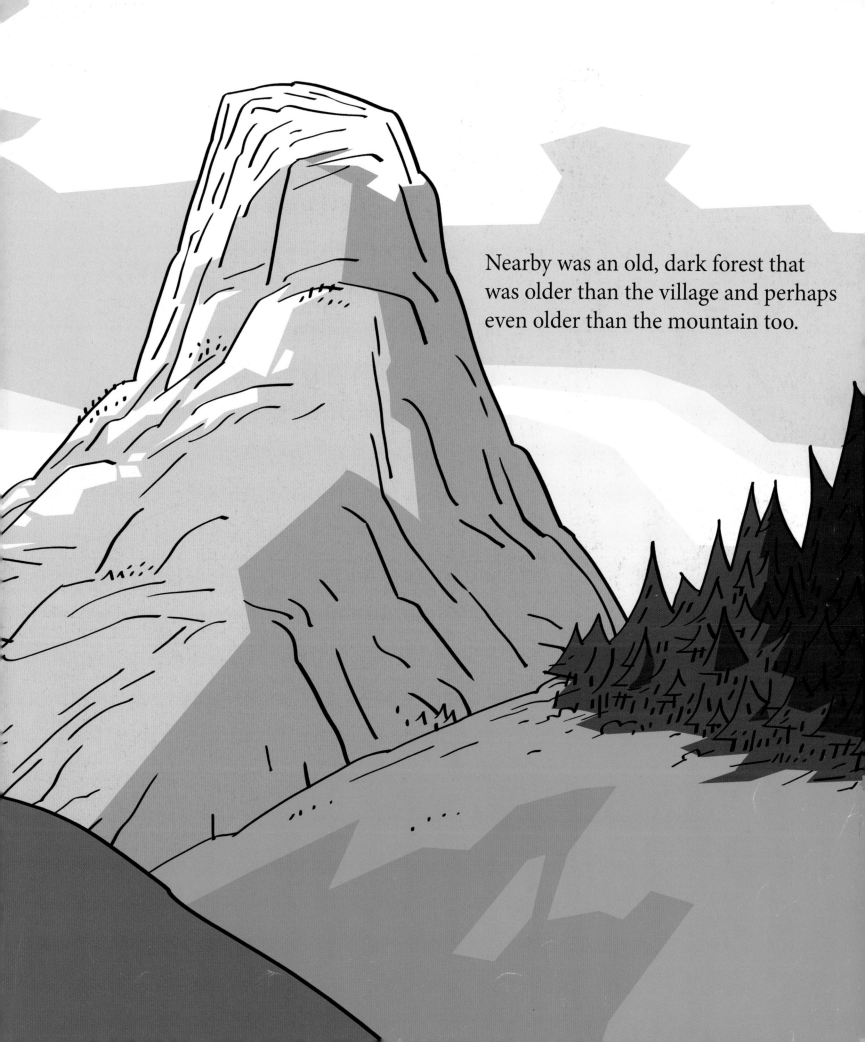

Nearby was an old, dark forest that was older than the village and perhaps even older than the mountain too.

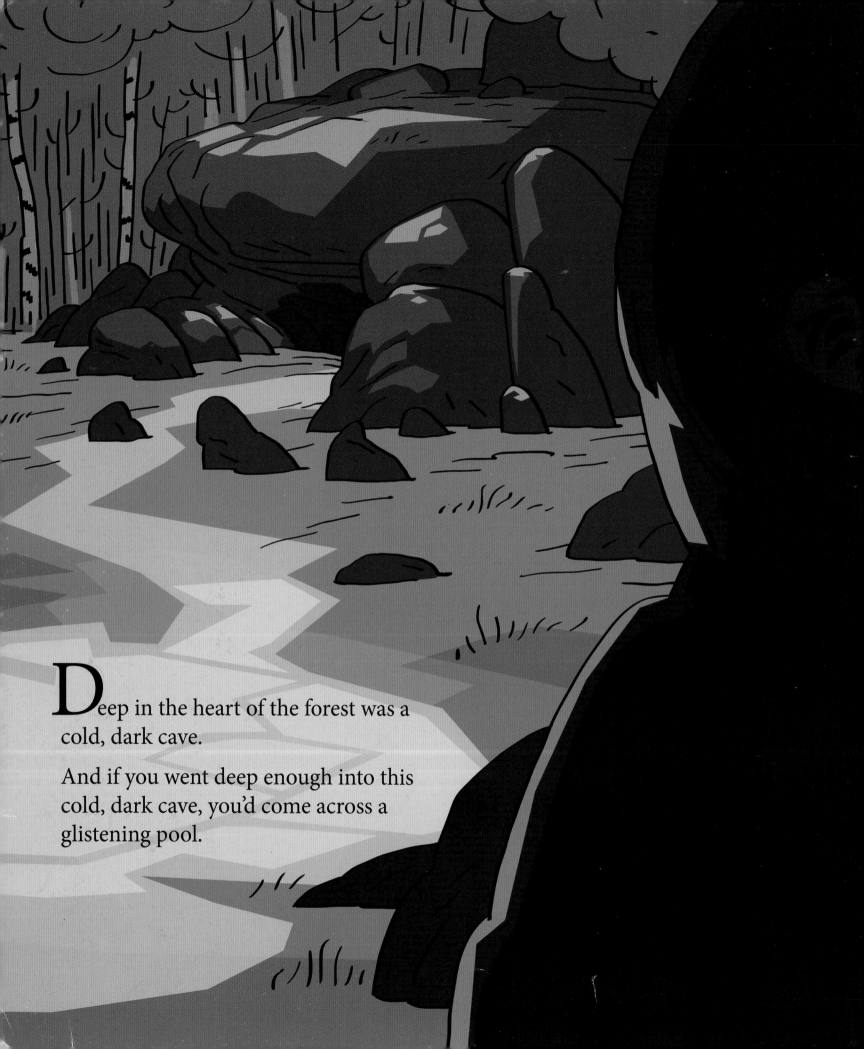

Deep in the heart of the forest was a cold, dark cave.

And if you went deep enough into this cold, dark cave, you'd come across a glistening pool.

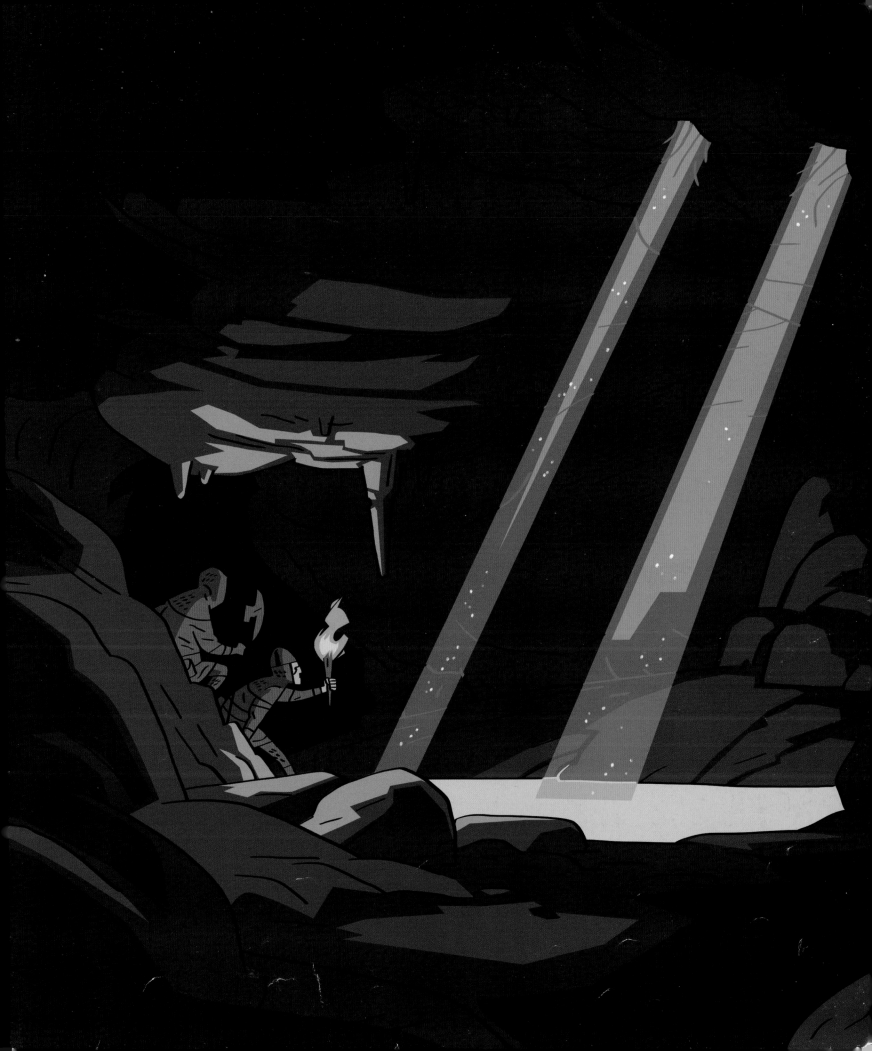

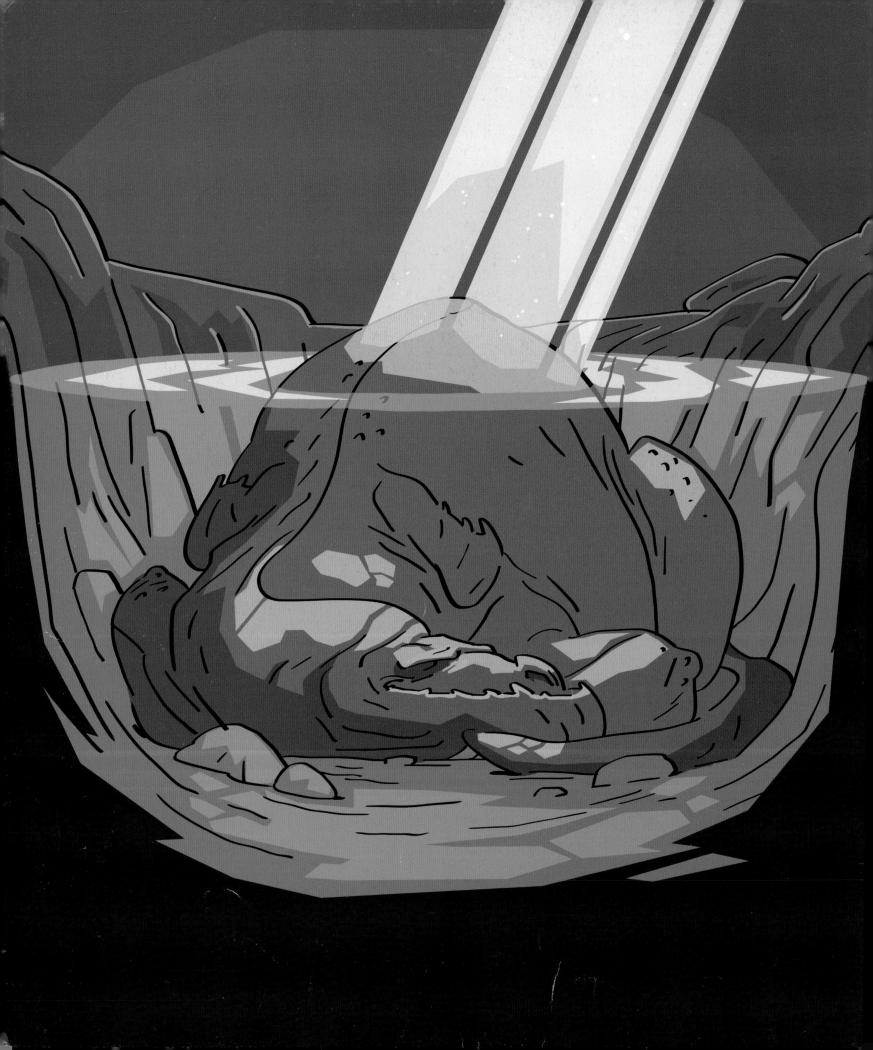

Curled up in the depths, right at the bottom, was a huge, brightly-coloured dragon.

All she wanted to do was sleep so she tried her best to ignore all the clattering that went on above her.

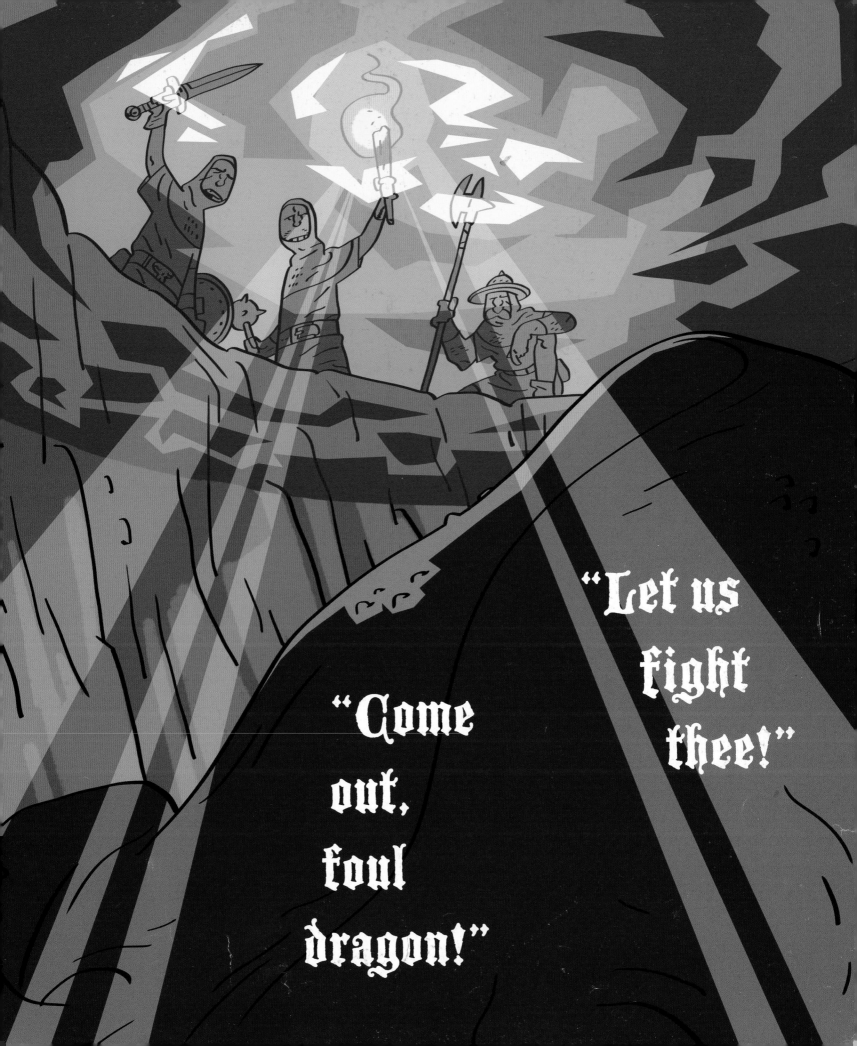

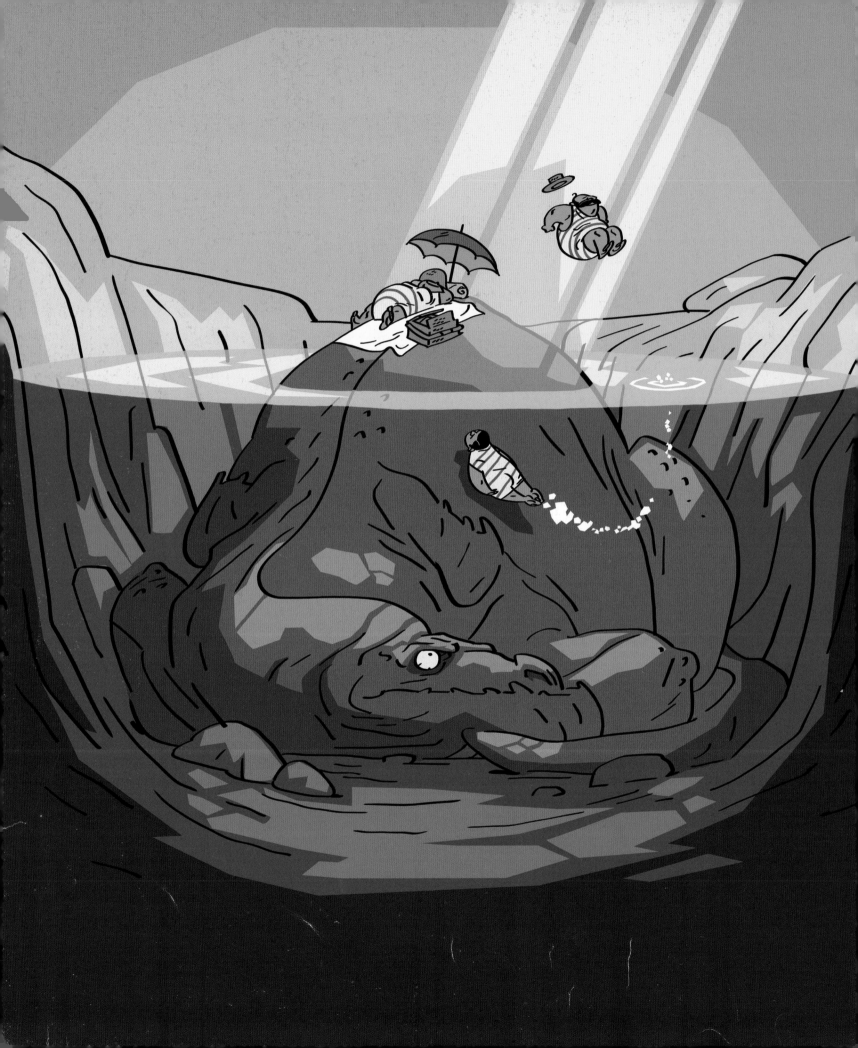

As bad as the knights were, at least they weren't as awful as the swimmers.

And the swimmers weren't as annoying as the fishing folk.

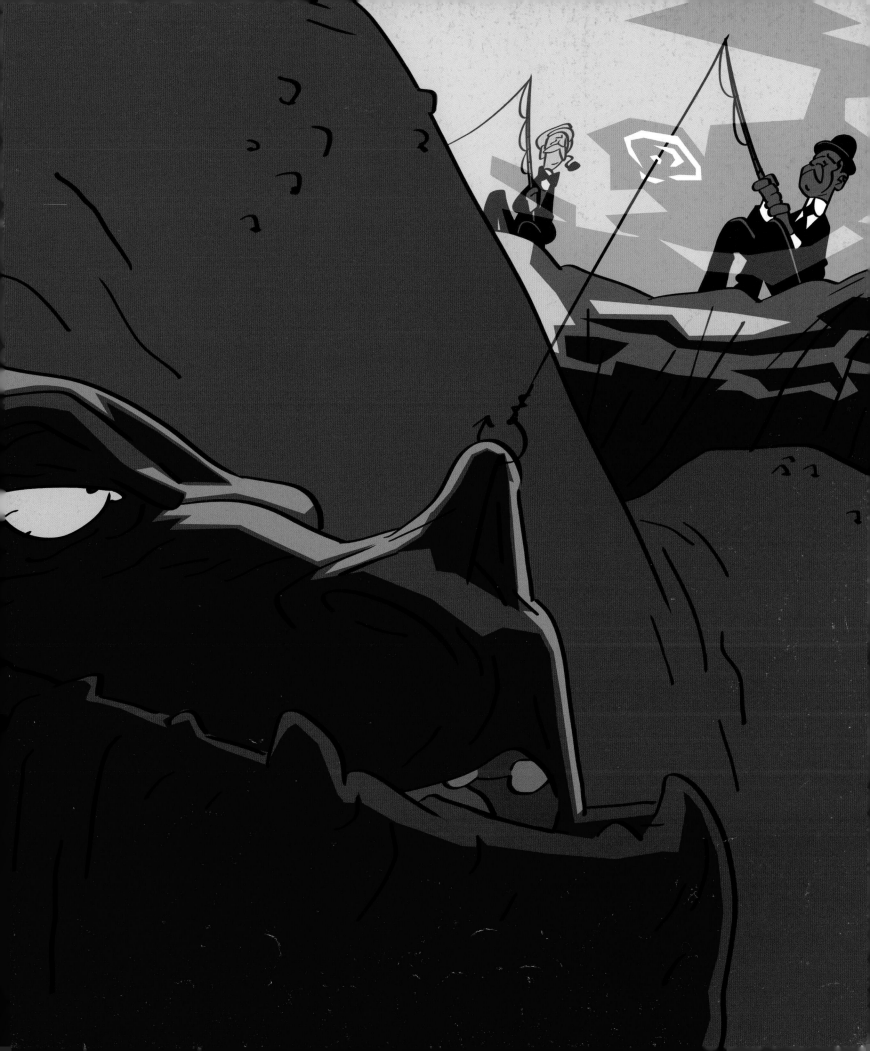

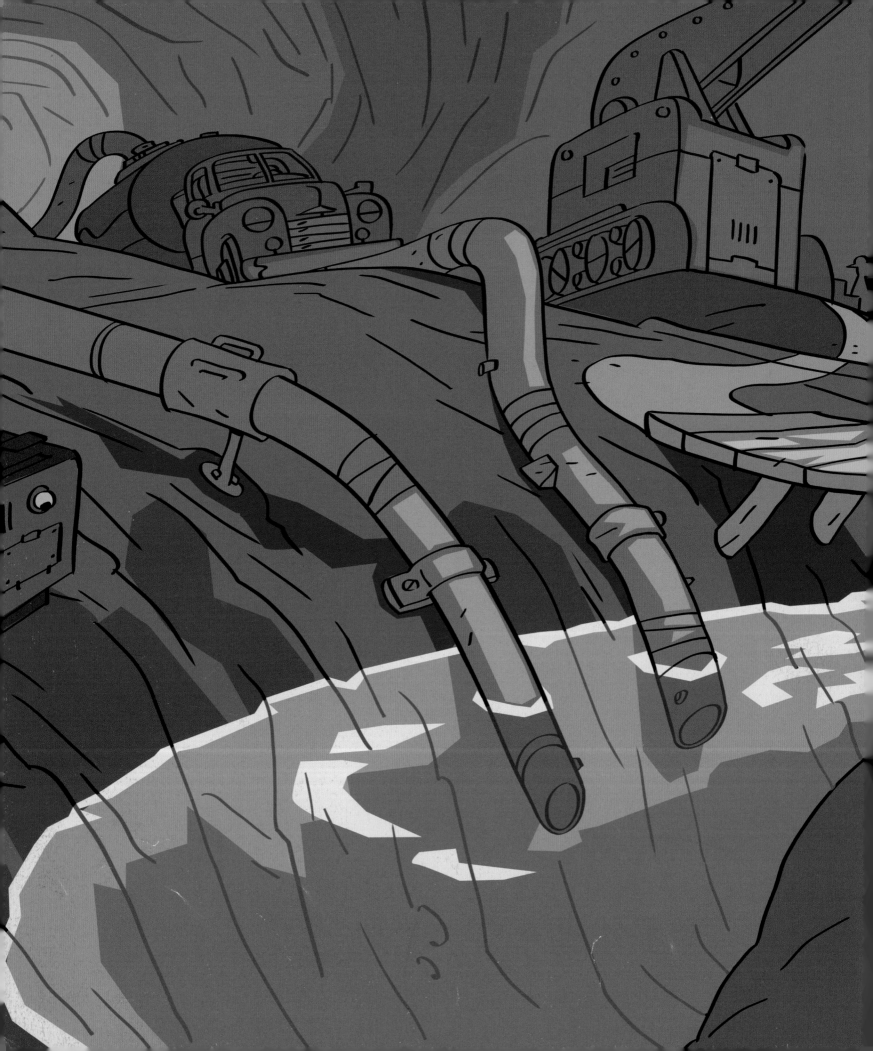

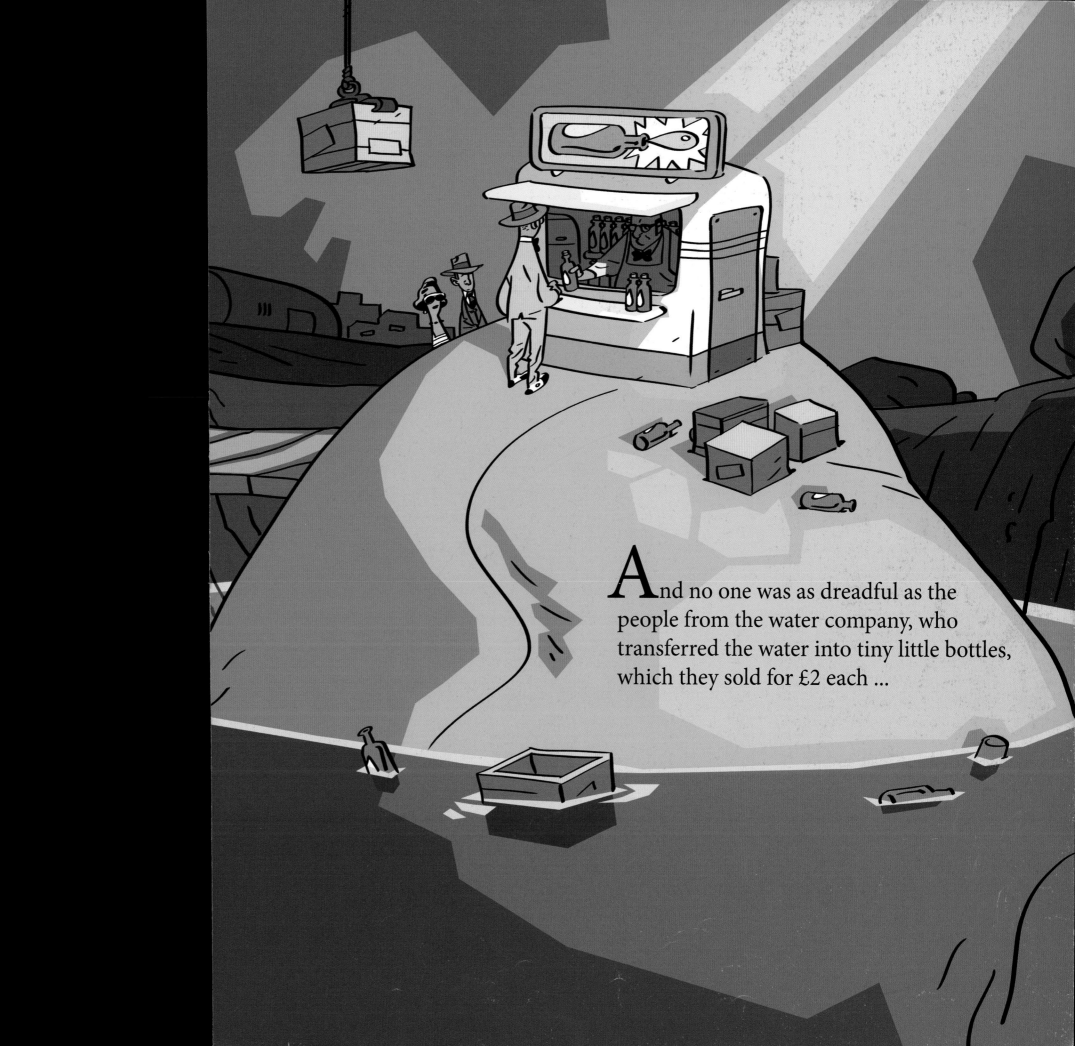

And no one was as dreadful as the
people from the water company, who
transferred the water into tiny little bottles,
which they sold for £2 each ...

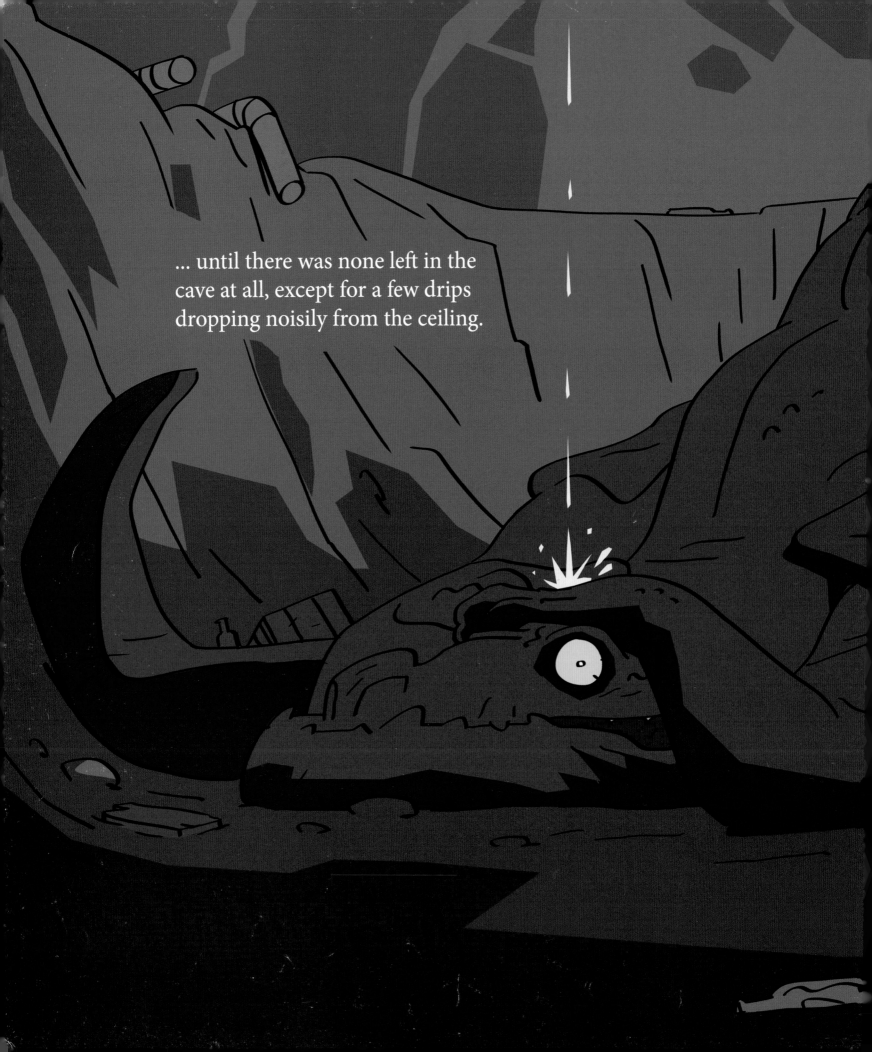

... until there was none left in the cave at all, except for a few drips dropping noisily from the ceiling.

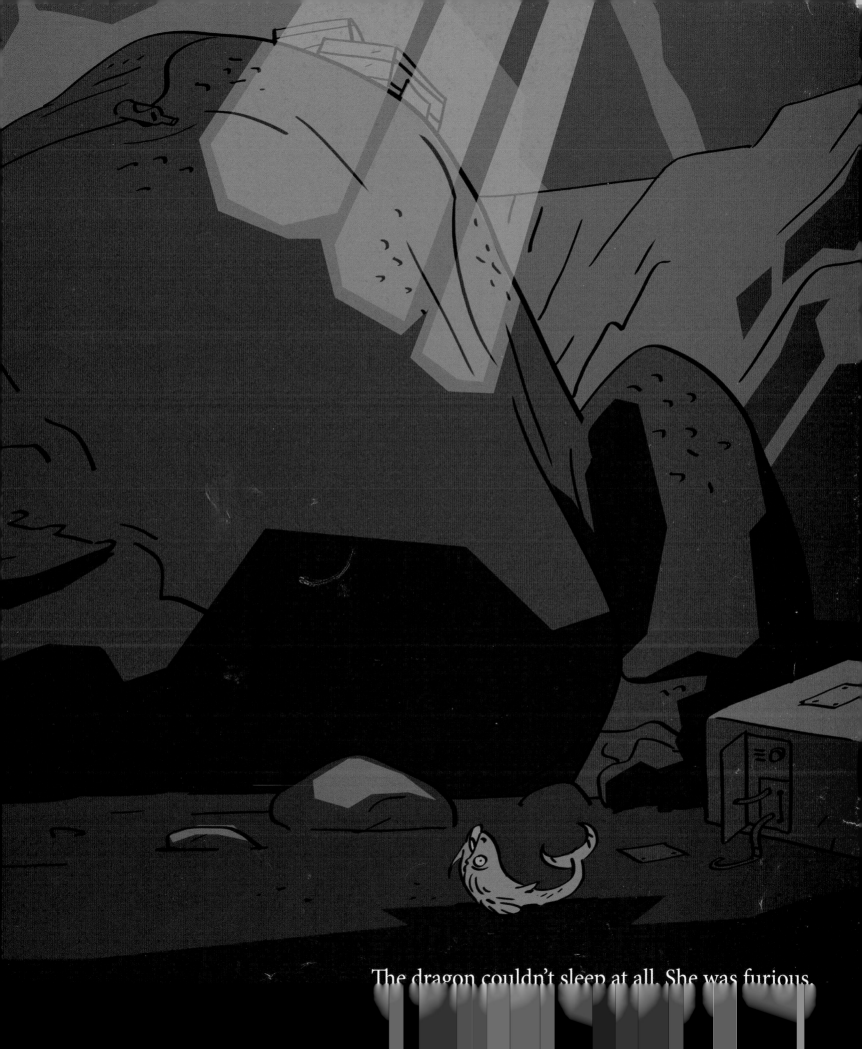

The dragon couldn't sleep at all. She was furious.

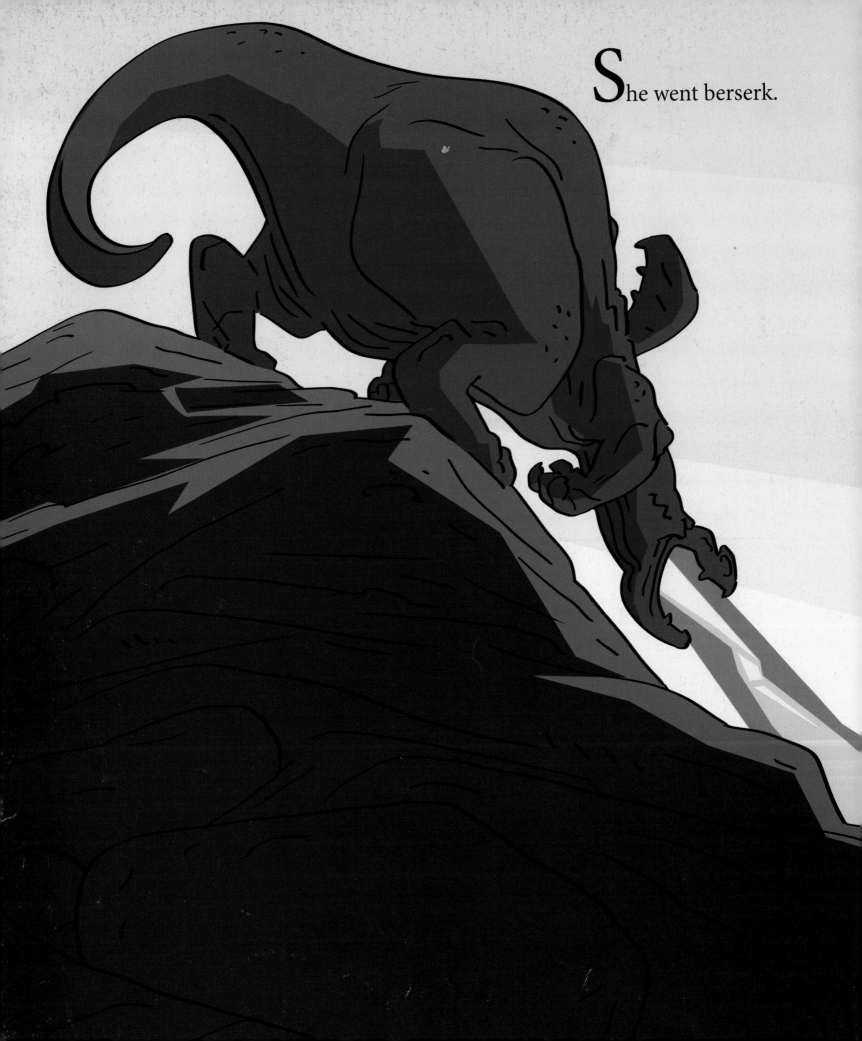

She went berserk.

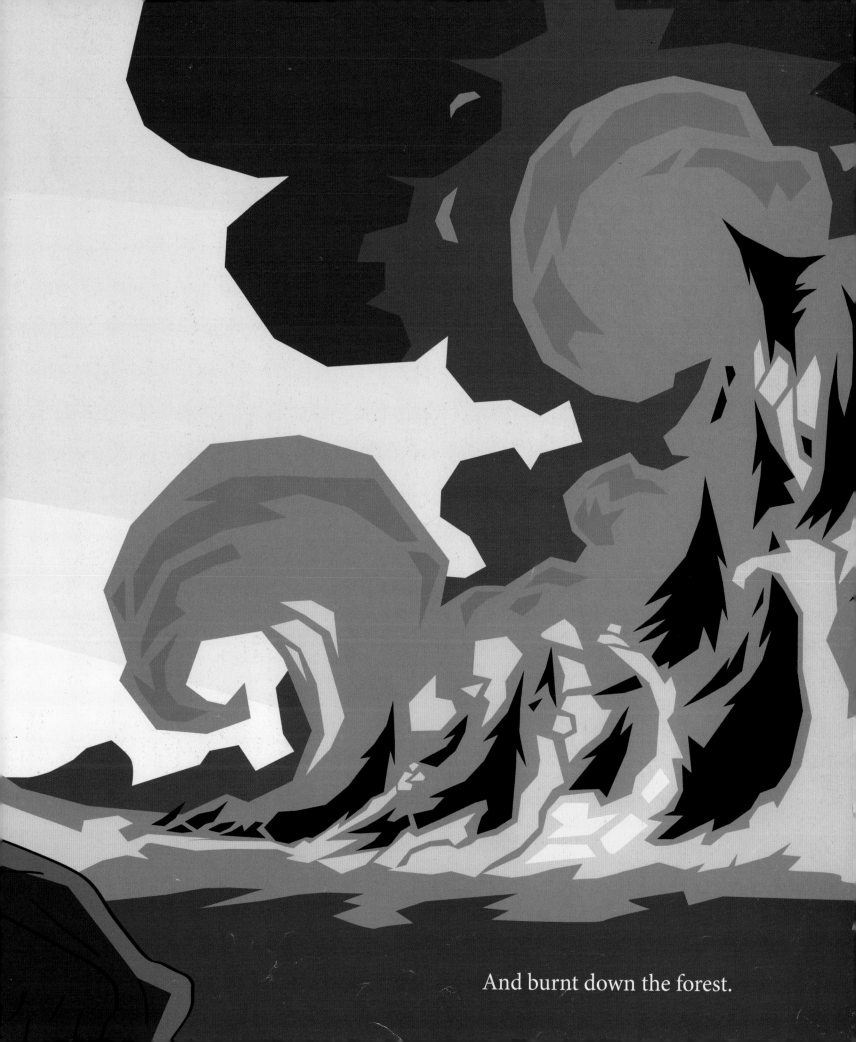

And burnt down the forest.

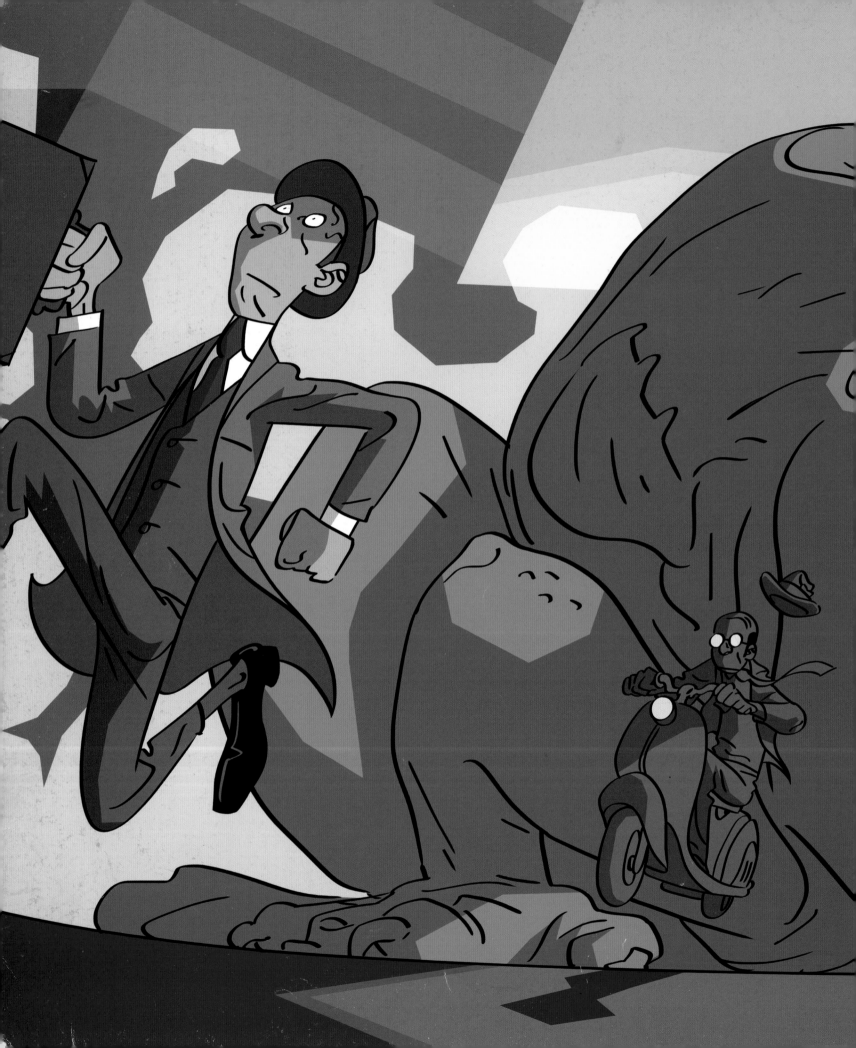

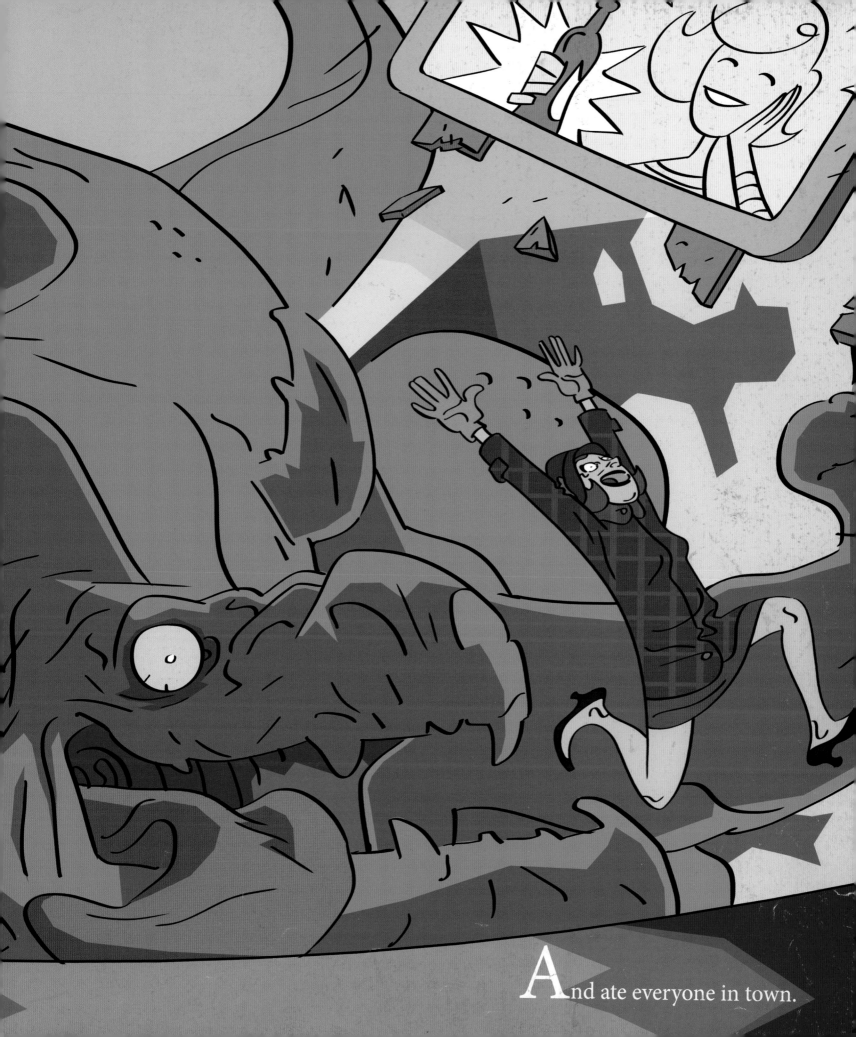

And ate everyone in town.

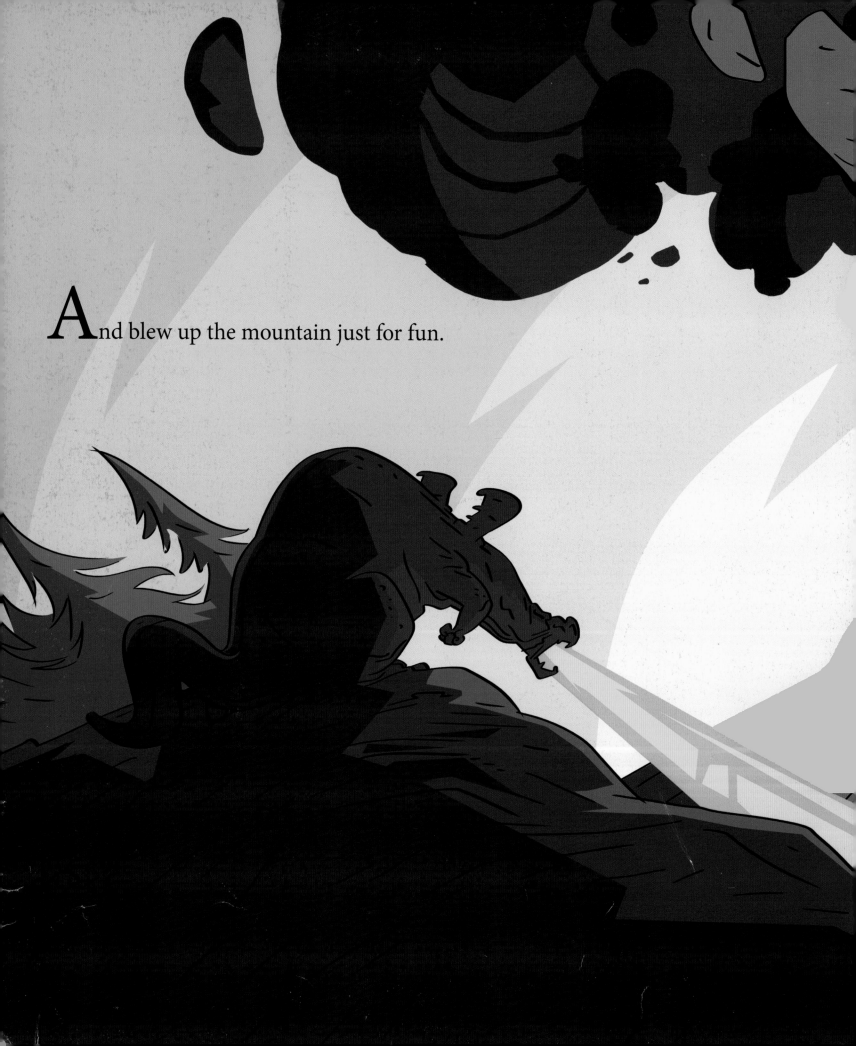

And blew up the mountain just for fun.

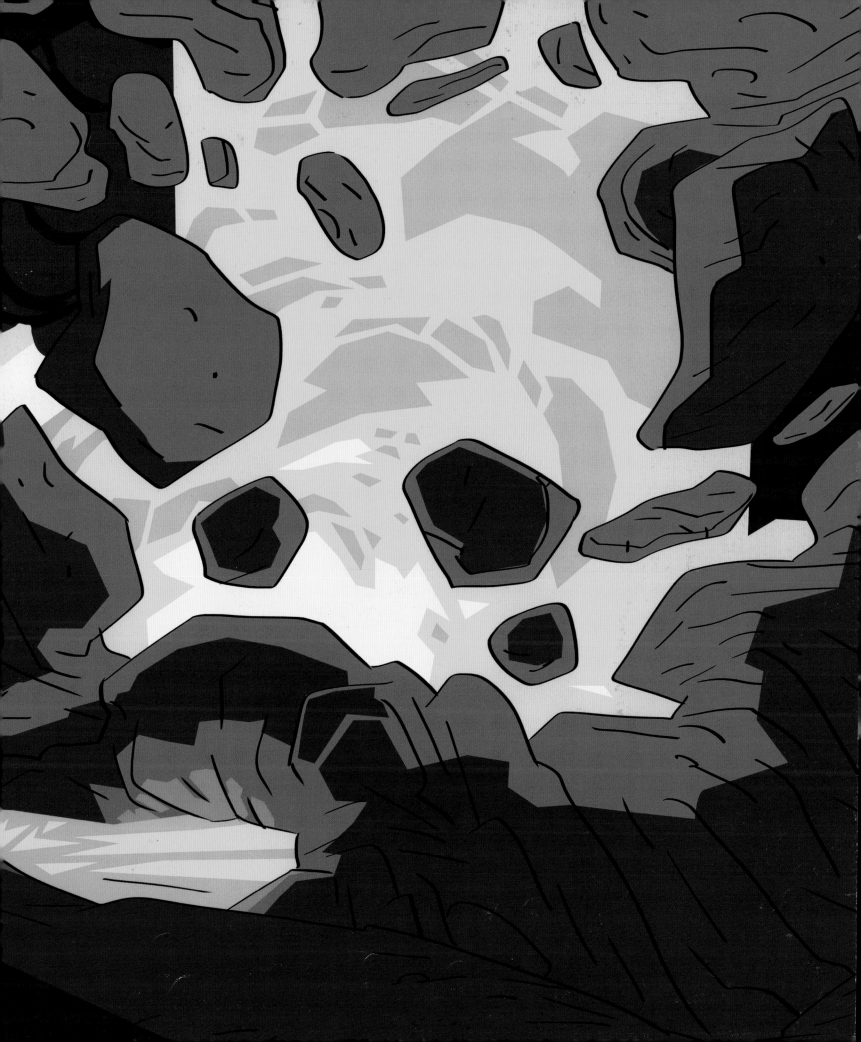

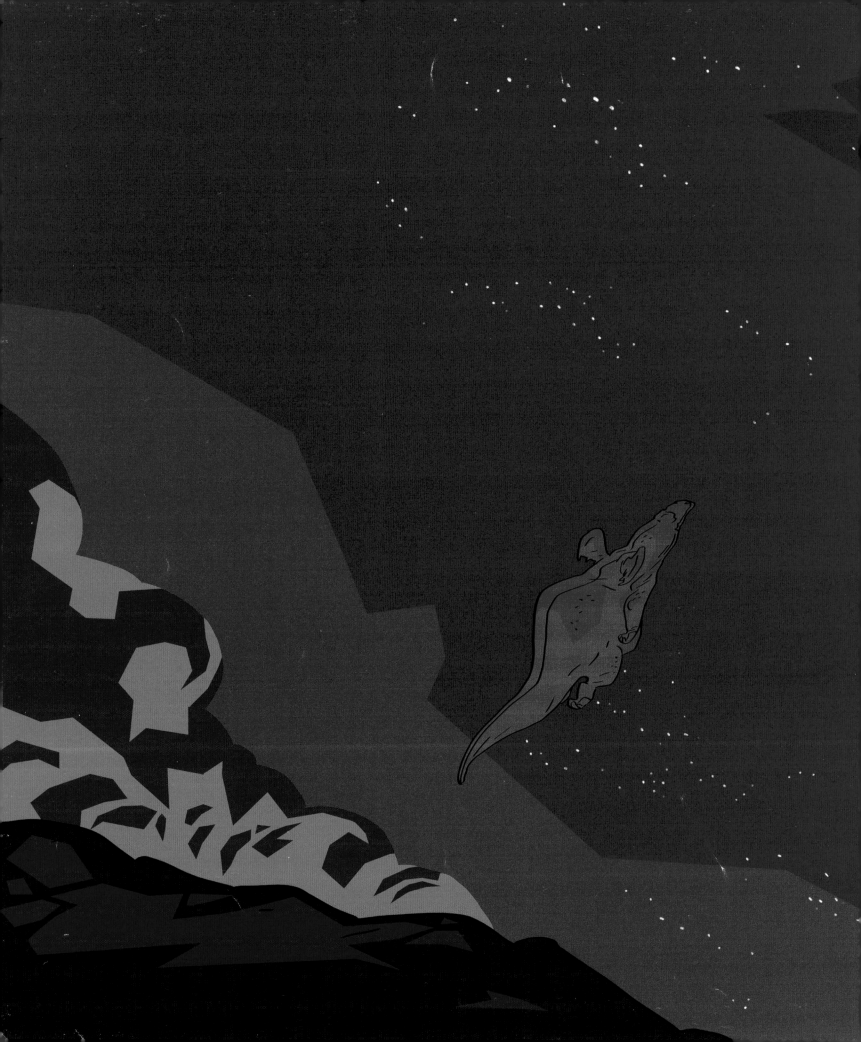

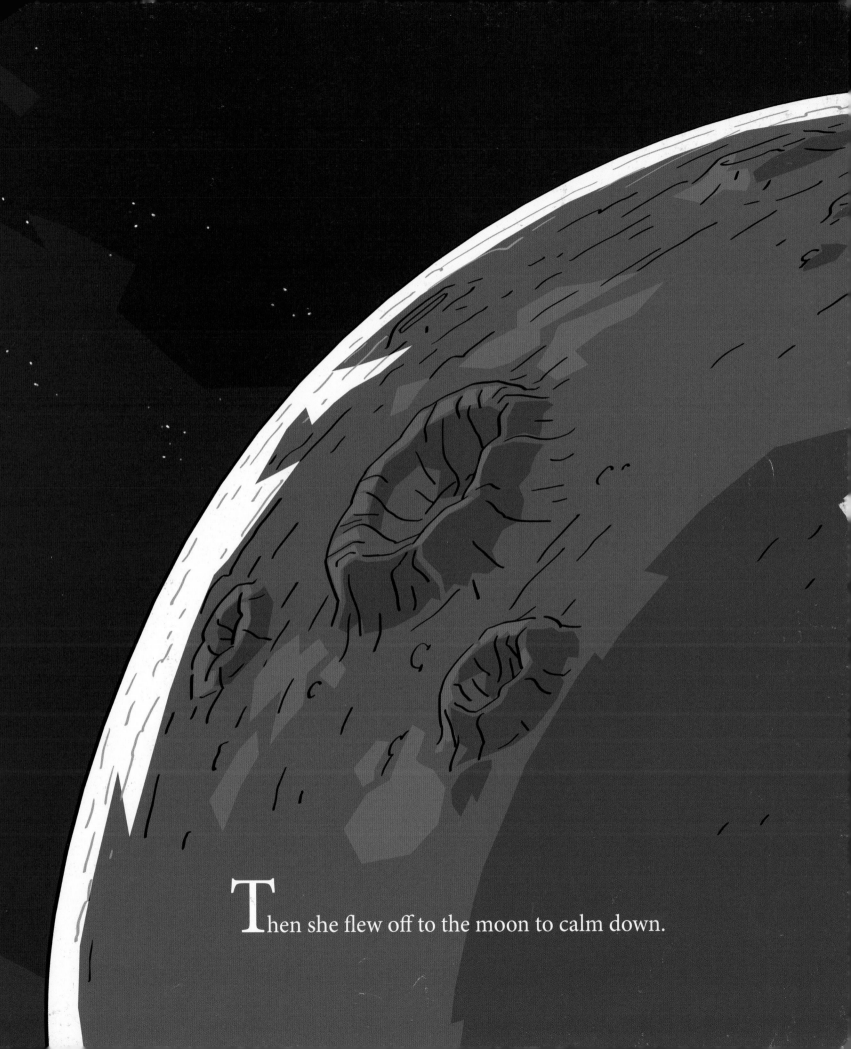

Then she flew off to the moon to calm down.

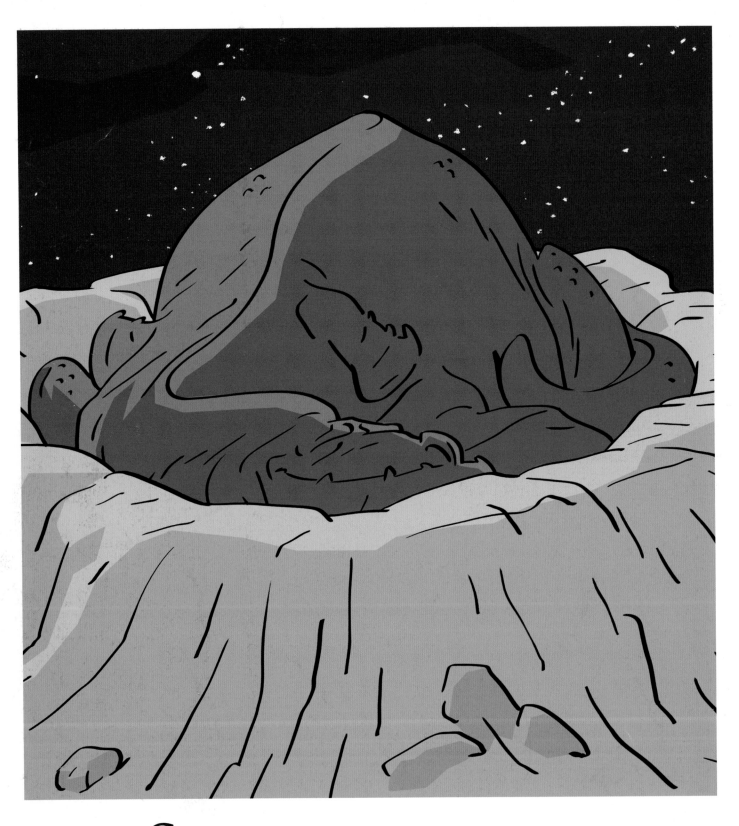

She curled herself up in a crater and buried her head in the sand, where she finally fell asleep.

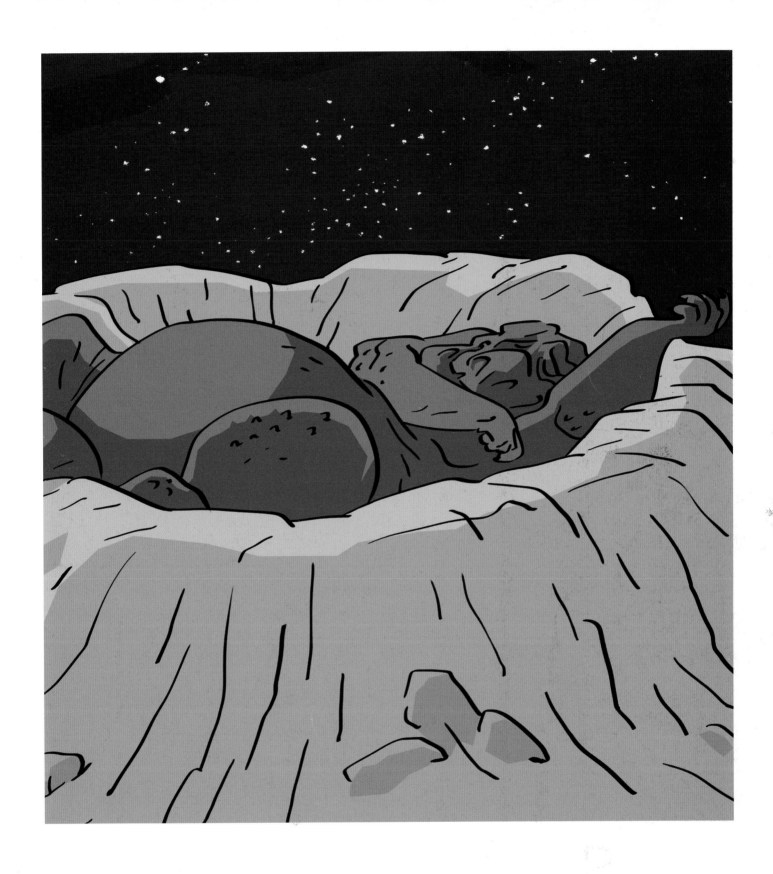

And stayed asleep, because the moon was so wonderfully quiet.

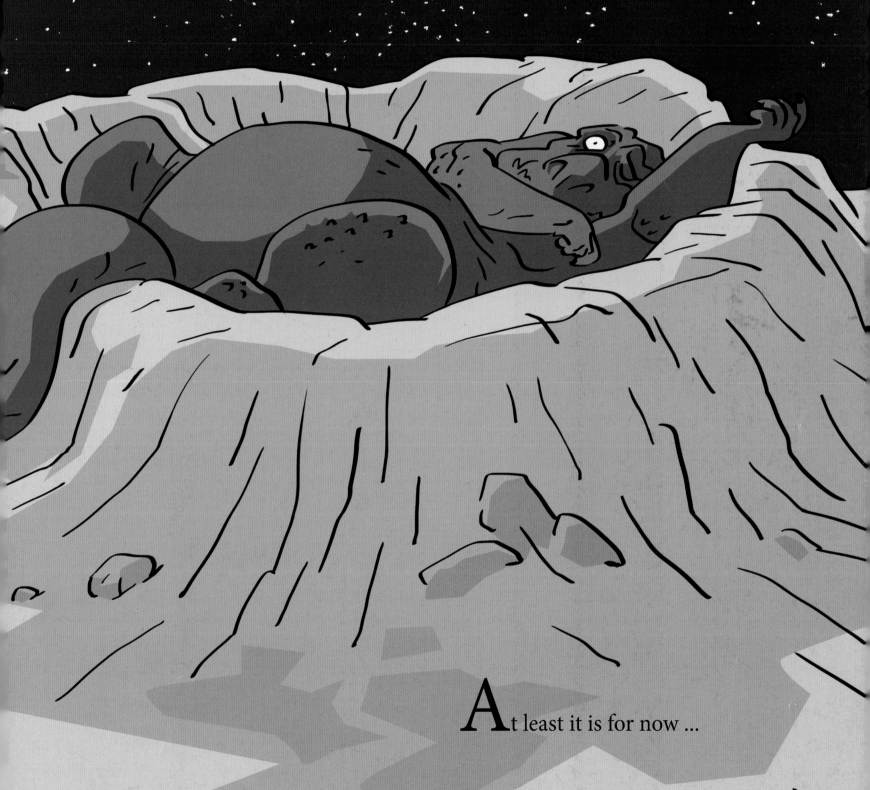

At least it is for now ...